THE WATSON GORDON
LECTURE 2016

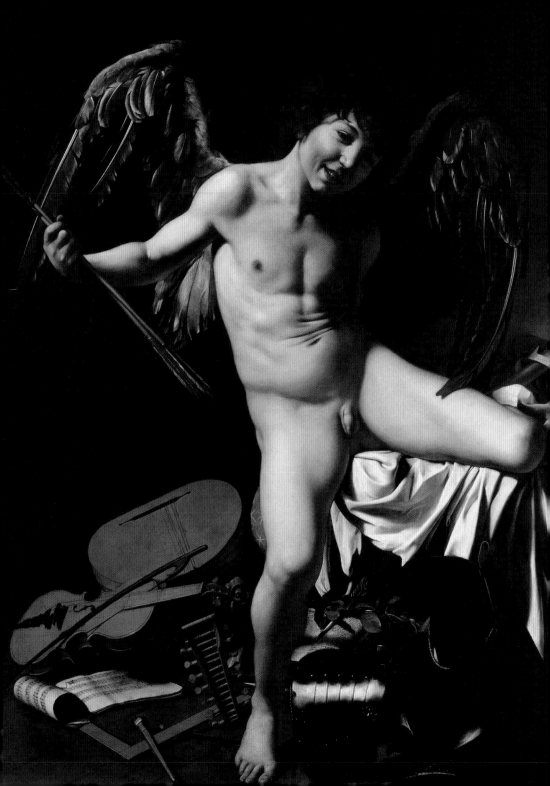

THE WATSON GORDON
LECTURE 2016

Caravaggio and Cupid: Homage and Rivalry in Rome and Florence

HELEN LANGDON

NATIONAL GALLERIES OF SCOTLAND
in association with
THE UNIVERSITY OF EDINBURGH

Published by the Trustees
of the National Galleries of Scotland, Edinburgh
in association with the University of Edinburgh
© The author and the Trustees of the National Galleries of Scotland 2017

ISBN 978 1 911054 14 6

Frontispiece: Michelangelo Merisi da Caravaggio,
detail from *Cupid Victorious, c.*1602 (fig.5)
Page 6: Michelangelo Merisi da Caravaggio,
detail from *Sleeping Cupid,* 1608 (fig.17)

Designed and typeset in Adobe Arno by Dalrymple
Printed on G-Print 150gsm
by Skleniarz, Poland

FOREWORD

The publication of this series of lectures has roots deep in the cultural history of Scotland's capital. The Watson Gordon Chair of Fine Art at the University of Edinburgh was approved in October 1872, when the University Court accepted the offer of Henry Watson and his sister Frances to endow a chair in memory of their brother Sir John Watson Gordon (1788–1864). Sir John, Edinburgh's most successful portrait painter in the decades following Sir Henry Raeburn's (1756–1823) death, had a European reputation, and had also been President of the Royal Scottish Academy. Funds became available on Henry Watson's death in 1879, and the first incumbent, Gerard Baldwin Brown, took up his post the following year. Thus, as one of his successors, Giles Robertson, explained in his inaugural lecture of 1972, the Watson Gordon Professorship can 'fairly claim to be the senior full-time chair in the field of Fine Art in Britain'.

The annual Watson Gordon Lecture was established in 2006, following the 125th anniversary of the chair. We are most grateful for the generous and enlightened support of Robert Robertson and the R. & S.B. Clark Charitable Trust (E.C. Robertson Fund) for this series, which demonstrates the fruitful collaboration between the University of Edinburgh and the National Galleries of Scotland.

The eleventh Watson Gordon Lecture was given on 24 November 2016 by Helen Langdon, the distinguished art historian. Her lecture enthralled the audience, wearing her enormous expertise on Italian Baroque painting lightly and illuminating Caravaggio's intense and tactile canvases with deep scholarship, a rich sense of literary and historical context and no little humour. This great painter grew and deepened before the audience's eyes as her lecture explored and exposed the nuances of his art.

RICHARD THOMSON
Watson Gordon Professor of Fine Art,
University of Edinburgh

SIR JOHN LEIGHTON
Director-General,
National Galleries of Scotland

[5]

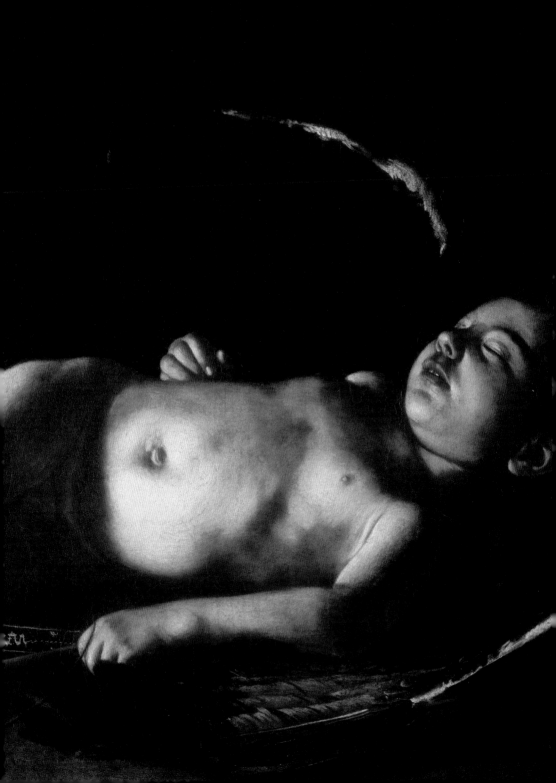

CARAVAGGIO AND CUPID:
HOMAGE AND RIVALRY IN ROME
AND FLORENCE

Cupid, the personification of amorous desire, is everywhere present in the Baroque, in a bewildering diversity of forms. Artists were attracted to Greek and Roman statuary and style, and consciously competed with the many Hellenistic Cupids that so delighted Roman collectors. They enjoyed the charming naturalism of these works, of chubby infants and sleeping Cupids, many of which look back to a celebrated bronze Cupid in The Metropolitan Museum of Art in New York, who lies peacefully at sleep, his bow cast off (fig.1). The fame of two works from Greek sculptors of the fourth century BC, a Cupid carving his bow, thought to be by Lysippos, and a Cupid long attributed to Praxiteles, stretched back to classical times.[1] The dangerous, even scandalous power of the latter was enhanced by an anecdote culled from Pliny the Elder, who tells us that so beautiful was it that 'a man from Rhodes fell in love with it and left upon it a mark of his'.[2]

Such pleasures were enhanced by the immensely popular *Greek Anthology* (*c.*700BC–AD1000), a collection of epigrammatic Greek poetry. The amatory epigrams, short, pointed and above all intensely visual, are often addressed to works of art that seem vividly alive and that wittily unite the absurd and the delightful. Several are addressed to Cupid, a rascal hated by all, setting new traps for hearts, a 'weaver of wiles' who mercilessly fires the dart that none can escape.[3] He is imagined as a small winged infant, naked and often blind, armed with a fiery torch or bow and arrow. This is the Cupid whom Lucas Cranach the Elder (1472–1553) shows at the side of his mother, Venus, in his *Venus and Cupid*; he seems to have clambered onto a pedestal, suggesting a sculpture or idol (fig.2).

Later in the sixteenth century Cupid grew older; he became an adolescent, now dangerous and seductive. The *Greek Anthology* included an idyll by Moschus (flourished *c.*150BC), entitled 'Runaway Cupid', the earliest description of Cupid that has come down to us in poetry and which evokes this malevolent youth in great detail. Here Venus, looking for her fugitive son, describes his piercing eyes

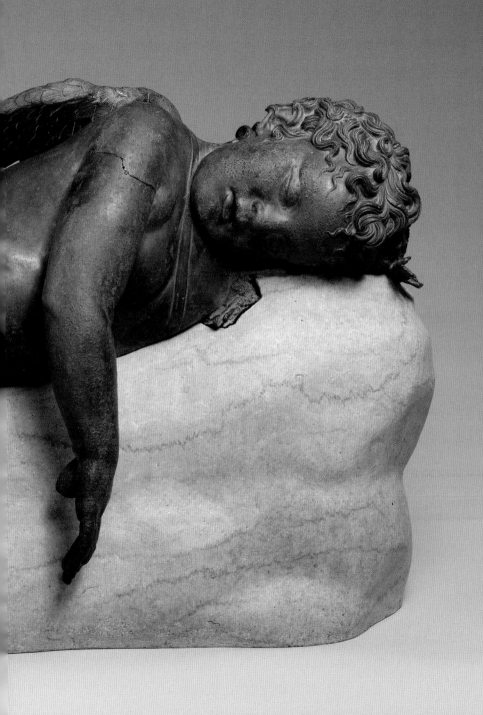

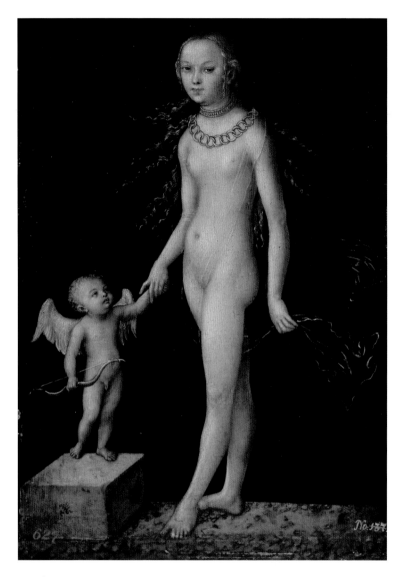

FIG.2 | LUCAS CRANACH THE ELDER
Venus and Cupid, c.1537
Oil on panel, 38.1 × 27 cm
Scottish National Gallery, Edinburgh. Bequest of the 11th Marquess of Lothian, 1941

and fiery complexion. Naked is his body, but his mind is 'wrapped up well'; he is, she warns, cunning, savage and pitiless, his arrows dangerous and his lips poison.[4]

Yet the *Symposium* (*c*.385–360 BC) by Plato (*c*.429–*c*.347 BC) had suggested that Cupid could also embody spiritual love or metaphysical desire, and had created a dichotomy between a heavenly Cupid and an earthly one. Heavenly love could inspire a love of wisdom and intelligence, and in his *Book of Emblems* (1531), learned humanist writer Andrea Alciato (1492–1550) showed the love of virtue overcoming lascivious love, who now weeps in misery.[5] Alciato presents the scene as a small painting, turning for inspiration to the *Greek Anthology*, in which a group of epigrams describe Cupid's chastisement and seem themselves to have been inspired by figurative models (fig.3). In Emblem XCVII, *In statuam Amoris*, he collects together the varied attributes of Cupid and creates a witty dialogue around them. Why, he asks, does a god who possesses all the riches of the world go naked? How could a feeble infant have subdued the mighty Nestor? Surely so heavy a bow would be unbearable to so small a child?[6] He is blind and yet, pointlessly, wears a blindfold. It was these ambiguities that so delighted artists and patrons and encouraged the pleasures of erudite conversation in the new picture galleries of seventeenth-century Rome.

In such a context the two paintings of Cupid by Michelangelo Merisi da Caravaggio (1571–1610), *Cupid Victorious* and *Sleeping Cupid*, established what was to be an immensely rich and evocative chain of images (figs 5 & 17). The Watson Gordon Lecture of 2016, on which this essay is based, was an introduction to the exhibition *Beyond Caravaggio*.[7] This presented a sequence of paintings of Cupid, and it is this rich imagery which forms my subject; I have tried to show how the artists of these works responded to Caravaggio, sometimes paying homage to him, at others rethinking his imagery.

CARAVAGGIO'S CUPID

Caravaggio painted *Cupid Victorious* around 1602 for Vincenzo Giustiniani (1564–1637), one of the most erudite and sophisticated patrons and collectors in Rome, to hang in his gallery at the Palazzo Giustiniani, in the city's centre. The subject is *Omnia Vincit Amor* (Love conquers all), a well-known Virgilian

motto (*Eclogues* x.69). It was new in painting, though it had appeared in prints. An anonymous sixteenth-century print, with a cheeky infant Cupid naughtily twanging his bow and treading on symbols of intellectual and military power, was well known and perhaps inspired Caravaggio's initial idea (fig.4).[8]

Cupid Victorious shows a young boy of about twelve, turned into Cupid by shaggy eagle's wings and perching, as though he had suddenly alighted there, on a tousled white sheet draped over a stone bench. Behind is a starry globe, and at his feet are symbols of the arts and sciences, of fame and of martial valour. In an inventory of 1638 it is described as '*un amore ridente, in atto di dispregiar il mondo*' ('Love laughing, as he scorns the world').[9] In 1673 the poet Giuseppe Michele Silos (1601–1674), in his *Pinacotheca sive Romana pictura e sculptura*, praised Caravaggio's 'most celebrated Cupid', the triumph of Caravaggio himself throughout the world. Silos perfectly captures the painting's spirit: Venus' son, with so lovely a face and so delicate a foot, tramples on all the achievements of

FIG.3 | BERNARD SALOMON (ATTRIBUTED TO)
Amor virtutis, alium Cupidinem superans, from Andrea Alciato's *Il Libro degli emblem,* 1556
Woodcut on paper

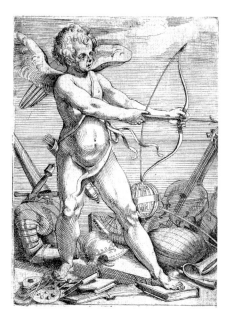

FIG.4 | UNKNOWN ARTIST
Omnia Vincit Amor,
*c.*1575–1600
Engraving, 21.6 × 15.8 cm
Private collection

the intellect; with laughter and amorous sighs, he humbles the armoured and fiery might of Mars, the god of war.[10]

Many analyses have moved away from these early responses, and certainly the painting's ambiguities and complexities would have delighted the learned Giustiniani. But I should like here to return to these first descriptions, and to privilege how freshly and how vividly Caravaggio has restored warm life to the seductive and malevolent Cupid of antiquity.

Most strikingly, Caravaggio's Cupid is alone, stripped of all context, no longer a bit-part player in elaborate mythological works. The Roman seventeenth century had opened with Annibale Carracci's (1560–1609) frescoed decoration of the vault of the Galleria Farnese (1597–1601) in the Palazzo Farnese, not far from the Palazzo Giustiniani, with scenes from *The Loves of the Gods*. Annibale's theme is again *Omnia Vincit Amor* and the artist created a heavenly sunlit world of ravishingly beautiful mythological lovers. Caravaggio's Cupid has emphatically descended to earth and to the bedroom, and his laughing presence was revealed to the viewer at the end of a tour of the Palazzo Giustiniani. The gallery was filled with an army of classical sculptures, mixing ancient works with modern in a new and startling way. Facing the entrance of the *galleria*, a group of ancient sculptures seemed to invite the viewer to enter. At their centre reclined a large, unexpected goat with Cupids on either side, one a version of the scandalous Praxitelean Cupid. No doubt his sophisticated visitors would have been aware of Pliny's scurrilous anecdote.[11]

The tone was witty, irreverent and highly personal. The climax of the tour, Caravaggio's *Cupid Victorious*, was concealed by a taffeta curtain to heighten expectancy and only revealed when all other treasures had been enjoyed.[12] The curator flung back the curtain, and Caravaggio's Cupid seemed to bring the classical sculptures of the *galleria* to warm life; at the same time, it threw out a challenge from painting to sculpture and from the modern world to the ancient. Such comparisons seem to have particularly delighted learned collectors. Isabella d'Este (1474–1539) had displayed ancient and modern Cupids together, in competition with one another, while in the Galleria Spada in Rome a display of three sculptures of *Sleeping Cupid* – one antique, a seventeenth-century version of the same subject,

and a workshop replica of Alessandro Algardi's (1595/8–1654) *Sleep, c.*1640 (Galleria Spada, Rome) – suggested how fashionable such comparisons remained.[13]

As the climax of the tour, this shamelessly erotic painting had immense shock value. Cupid boldly confronts the viewer. He seems about to speak, and may have suggested contemporary theatre or masque, where Cupid often plays a role. In Torquato Tasso's (1544–1595) *Aminta* (1573), for example, the prologue, adapted from Moschus' idyll, is spoken by Cupid. In the painting, the boy is lit from above, light and dark playing vividly over the forms and flesh, the tip of the wing against the thigh creating a sensual shiver and directing the viewer's gaze. His foot has just touched the floor and he seems on the edge of tumbling into our space. The position of his left hand is ambiguous: is it balancing him, or is it an invitation to erotic pleasure? Or maybe he is contemptuously farting or even defecating on all the glorious trappings of civilisation. His laughter suggests supreme confidence and his naked beauty is his weapon. His face is compellingly close to the viewer and he challenges him with his arrows, one gold, one of lead. These arrows had contrary effects, the gold creating love, the lead indifference to love. Cupid's intent was malign and he aimed to spread maximum unhappiness and confusion.[14]

This learned work is full of the spirit of the *Greek Anthology*, for this is Moschus' cunning and pitiless Cupid, his flesh like fire, with 'plenty of hair on his head, and … a most forward face'.[15] Moschus' idyll had been well known in sixteenth-century Medicean Florence and Caravaggio pits his vivid boy against the idealisations of sixteenth-century art. Bronzino's (1503–1572) Cupid in his *An Allegory with Venus and Cupid*, his hair so exquisite and blond, is, by contrast, a celebration of the artifice of art (fig.6). His bottom, however, is yet ruder than that of Caravaggio's Cupid and both artists were invoking the humour of the *Greek Anthology*, much of which was homoerotic. Giustiniani and Caravaggio may well have responded to the tone of Strato's epigram (*c.*AD100–300):

> *As Adrian's naked bottom pressed*
> *That wooden bench, it pinched his cheeks;*
> *I tremble to love such a boy,*
> *That even wood desires and tweaks*[16]

The shock would have been enhanced by the viewer's recognition of Caravaggio's

FIG.5 | MICHELANGELO MERISI DA CARAVAGGIO
*Cupid Victorious, c.*1602
Oil on canvas, 156.5 × 113.3 cm
Gemäldegalerie, Staatliche Museen zu Berlin, Berlin

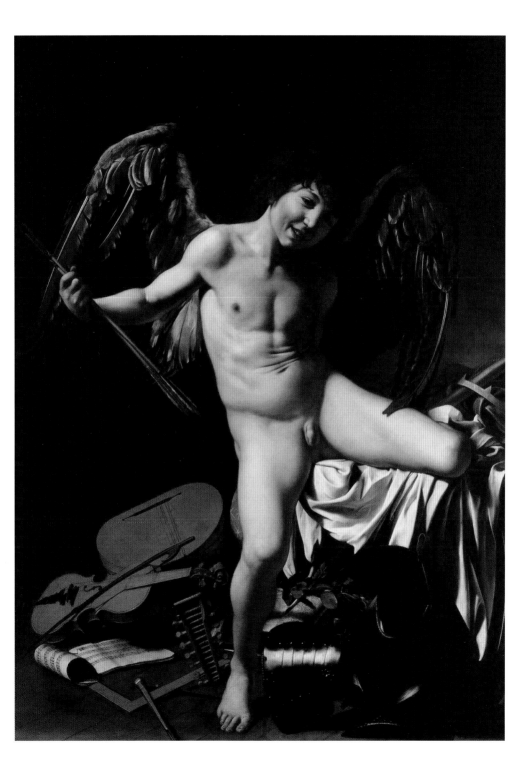

FIG.6 │ BRONZINO
*An Allegory with Venus and Cupid, c.*1545
Oil on wood, 146.1 × 116.2 cm
The National Gallery, London

FIG.7 | PAOLO VERONESE (CALIARI)
*Mars, Venus and Cupid, c.*1580
Oil on canvas, 165.2 × 126.5 cm
Scottish National Gallery, Edinburgh. Purchased by the Royal Institution 1859;
transferred to the National Gallery of Scotland, 1867

model, who appears in other paintings, scandalously thrusting the world of the street into Giustiniani's palazzo, a refined home to all learning.[17] This street boy tramples on the arts, and perhaps Caravaggio here makes fun of the belief expressed in Plato's *Symposium* that the love of beautiful boys leads to the love of spiritual beauty.[18] Cupid does not, however, trample on an artist's palette as he does in the print; this Cupid is the triumph of Caravaggio himself, or of naturalistic painting.

Caravaggio's painting immediately became celebrated. Its illusionism and the vividness of the flesh seemed wondrous to seventeenth-century commentators, who did not comment on the shocking nature of the image. Its influence spread rapidly. Giulio Mancini (1559–1630), the first biographer of Caravaggio, describes a small group of painters who formed the '*schola*' of Caravaggio, among them Bartolommeo Manfredi (1582–1622), who adopted his style with 'vigour and knowledge', and Carlo Saraceni (1579–1620), who 'partially' followed him.[19] These artists took up the subject of Cupid, the latter in a small and exquisite *Venus and Mars*, where the presence of Caravaggio makes a token but intriguing appearance, and the former in a large and violent *Cupid Chastised* (figs 8 & 13).

In Caravaggio's *Cupid Victorious* the presence of Mars is implicit. Silos, as we have seen, tells us that Cupid tramples on his arms, but both Saraceni and Manfredi turn to the ever-popular fable of Venus' adulterous dalliance with Mars, the god of war, who was well known as antithetical to Cupid. The subject had been a favourite in the sixteenth century; Paolo Veronese's (*c.*1528–1588) *Mars, Venus and Cupid* shows the lovers in a twilight setting and adds the comic scene of Venus' lapdog climbing on Cupid and interrupting the delicate unveiling of his mother's white skin (fig.7). Many sixteenth-century makers of mythological prints, in both northern Europe and in Italy, also delighted in the humorous erotic possibilities the story offered, for their dalliance comes to a bad end. Vulcan, the old and lame blacksmith husband of Venus, discovers their treachery and catches the naked gods in a humiliating net, to the uproarious delight of the gods of Olympus.

Saraceni's *Venus and Mars* is rooted in these sixteenth-century traditions.

He would have known Sodoma's (1477–1549) *Marriage of Alexander and Roxana*, 1519 (Villa Farnesina, Rome), where putti gambol around the lovers' canopied bed; the overlapping legs of his gods are derived directly from Giulio Bonasone's (*c.*1510 – after 1576) print of *Venus and Mars*, from his series *The Loves of the Gods* (1531–60; fig.9). Saraceni tempers their exuberant eroticism with a clearer composition and less riotous figures.[20] Vulcan's palazzo is evoked by an elaborate architectural setting, a fantastical blend of Colosseum, temple and opulent boudoir. Saraceni has, unusually, chosen a moment of stillness: the putti play busily; Mars' sword, cast off, rests resplendent against the tiled floor; and the two lovers are transfixed at a high moment of sexual abandon, their classical beauty, so bright against the dazzling whiteness of the sheets, is celebrated. Yet this captivating, sensual image is given tension by the suggestion of impending disaster. The moving statues, one a warrior and perhaps an alter ego and reproof to Mars, gesticulate and gesture towards Vulcan's forge, glimpsed at the end of the colonnade, whence revenge will come. Gods in niches, bursting out of their settings or balancing on the edge, had been popular with sixteenth-century printmakers. Gian Giacomo Caraglio (*c.*1505–1565) had produced a series of twenty such prints (*The Gods in Niches*, 1526), among them a Vulcan, wielding his hammer and posing at the niche's edge (fig.10).[21] His print of *Mars and Venus Surprised by Vulcan* of unknown date juxtaposes the Hellenistic/Roman *Medici Venus* (Galleria degli Uffizi, Florence) with two lovers in flagrante.[22]

In William Shakespeare's (1564–1616) heroic narrative poem, 'Venus and Adonis' (1593), Venus boasts of her triumph:

> *Over my altars hath he hung his lance,*
> *His batter'd shield, his uncontrolled crest,*
> *And for my sake hath learned to sport and dance,*
> *To toy, to wanton, dally, smile and jest …*

Soon she too will be ensnared and, in Saraceni's picture, a putto at the foot of the bed throws back the sheet, ready to pounce on a gilt image of a crouching and fearful Venus. At the base of the sumptuous painted curtain an onlooker or voyeur is poised to erupt into the room, perhaps a prelude to the gods who will soon be summoned to mock the adulterous pair, and who featured in illustrated editions

FIG.8 | CARLO SARACENI
*Venus and Mars, c.*1600
Oil on copper, 39.5 × 55 cm
Carmen Thyssen-Bornemisza Collection, on loan to
the Museo Thyssen-Bornemisza, Madrid

of Ovid's (43 BC–AD 17) 'Metamorphoses'. The small painting is a tour de force of
virtuoso illusionism, a play on different levels of artifice and reality, which recalls
something of Annibale's wit in the scenes of *The Loves of the Gods* on the vault of
the Galleria Farnese.

Saraceni was, however, 'partially' a follower of Caravaggio, and hints of the
modern world are woven into the texture; Mars is a contemporary warrior, his
rapier and helmet insistently modern, and the onlooker sports a vivid red con-
temporary hat. Cupid himself seems a direct homage to Caravaggio: he is rooted

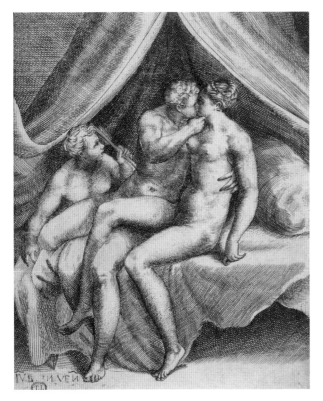

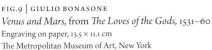

FIG.9 | GIULIO BONASONE
Venus and Mars, from *The Loves of the Gods,* 1531–60
Engraving on paper, 13.5 × 11.1 cm
The Metropolitan Museum of Art, New York

FIG.10 | GIAN GIACOMO CARAGLIO
*Vulcan Standing Naked Swinging a Hammer
above his Head,* 1526
Engraving on paper, 21 × 11 cm
British Museum, London

in nature, albeit idealised; he urinates on Mars' helmet and admires his reflection
as he does so in Mars' shield. Cupid seems to be applauding his own skill in bring-
ing low the mighty god of war and the reflection in the shield is a display of the
painter's illusionistic skill, an echo of the radical art of Caravaggio. This Cupid
seems to stand between the classicism of Bolognese artists (Annibale had painted
a pissing Cupid in the Galleria Farnese, next to Polyphemus and Galatea; fig.11)
and the provocative modernity of Caravaggio. He stands at the corner of a paint-
ing rooted in sixteenth-century eroticism and in Venetian art, pointing the way

forward to the new naturalism.[23] Small rooms dedicated to the display of highly erotic pictures had begun to appear in Roman collections in the early seventeenth century and this painting may have been in the *salone* of the Palazzo Altemps, along with three nude Venuses.[24]

Manfredi's *Cupid Chastised* was commissioned by Mancini on behalf of a Sienese patron, Agostino Chigi (*c.*1465–1520), Rettore of Santa Maria della Scala in Siena, in 1613. Mancini had initially wanted to acquire a copy of a now-lost painting by Caravaggio, a *Divine Love who Subjugated the Profane*, but, failing that, asked for this work from Manfredi.[25] Chigi enjoyed the subject and later bought Astolfo Petrazzi's (1580–1653) *Cupid with the Attributes of the Arts* (Galleria Nazionale d'Arte Antica, Rome) and the *Sacred and Profane Love* (The Israel Museum, Jerusalem; dates of both unknown) attributed to Rutilio Manetti (*c.*1571–1639), creating a sequence of works that engage one another.[26] It seems likely that Manfredi's painting is a free interpretation of a Caravaggio prototype, rather than a copy.

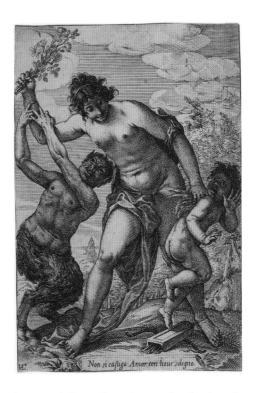

Cupid Chastised could hardly be more different from Saraceni's refined work. It is large, dark and brutal, and seems to invade the space of the viewer rather than drawing him into a miniature world. The punishment of Cupid was a common theme in Greek poetry. Sometimes he is castigated by heavenly love; he may be thrashed, bound, his bows and arrows broken and his wings torn from his back. Often his enraged mother, Venus, tries to punish him but, as she grumbles to Selene in Lucian's (AD 120 – after 180) comic *Dialogues of the Gods,* all in vain: 'I'll smash his archery set and strip off his wings. Last time I even took my sandal to his behind. But somehow or other, though he's scared for the moment and begs for mercy, it's not long before he's forgotten all about it'.[27] As we have seen, Alciato's Emblem LXXII, showing the love of virtue overcoming lascivious love, presented the little scene as a painting. It is perhaps not coincidental that an unusually violent fresco by Luca Signorelli (*c.*1440/50–1523) in the Palazzo del Magnifico in Siena, which depicts *The Triumph of Chastity: Love Disarmed and Bound,* about

[23]

1509 (now The National Gallery, London) was then famous in the city, which was the intended home of Manfredi's picture.[28] Seventeenth-century lyric poets, above all Cesare Rinaldi (1559–1636) in Bologna, delighted in the theme; Rinaldi weaves conceits around the idea of blind Cupid, of the sweetness and pain of love, and devotes a sequence of poems to Cupid's punishment.[29] The great Baroque poet Giambattista Marino (1569–1625), a friend of Caravaggio, opens his heroic epic poem, 'Adone' (1623), with Venus punishing Cupid by beating him with a rose branch. In Bologna the subject was a favourite motif of erotic printmakers, in which the mischievous child suffers the wrath of a furious mother (fig.12).

Manfredi's painting is rooted in the mock-heroic tradition of Lucian and he shows a threatening scene of domestic violence, caught at its climax. Mars, probably Cupid's father and furious at his humiliating subjection to Venus, seizes his son and is about to beat him harshly with a rope flail. It is a savage image, the whip so tactile and solidly painted, Cupid's flesh translucent and his pose vulnerable, with the blindfold, a symbol of sin, serving to heighten the erotic sadism as he moans in pain. Venus, ungainly and unidealised, scrabbles on the ground to retrieve Cupid's broken arrows, protesting in vain. The painting has the feeling of a street brawl, Venus' doves, now pigeons, fluttering away from the tumult. The painting still today shocks and disturbs with its sexual violence. Its high point is certainly Cupid, and the patron complained that Venus was inferior, but Manfredi's strong bright colours, with the bold red evoking violence, his sharp detail and directed light suggest how passionately he was rivalling Caravaggio. He perhaps had in mind the dark street scene in Caravaggio's *The Martyrdom of Saint Matthew* in the Roman church of San Luigi dei Francesi, and his setting of Mars' head and hand at the centre of crossing diagonals echoes that composition (fig.14). Manfredi brings to mythological painting that sense of the here and now with which Caravaggio invested religious scenes. The latter had, too, brought ancient sculpture to life in his painting of Cupid, and the sculptural grandeur of Manfredi's painting recalls the well-established ancient sculptural tradition of the warrior and his victim.

FIG.13 | BARTOLOMEO MANFREDI
Cupid Chastised, 1613
Oil on canvas, 175.3 × 130.6 cm
Art Institute of Chicago, Chicago

FIG.14 | MICHELANGELO MERISI DA CARAVAGGIO
The Martyrdom of Saint Matthew, 1599–1600
Oil on canvas, 323 × 343 cm
San Luigi dei Francesi, Rome

Caravaggio's Cupid was not often copied, but it was immediately celebrated and its fame endured. Painters clearly knew the work and in the next two decades echoed the composition and theme. Some delighted in the provocative sexuality, adopting and even exaggerating the daring frontal pose; others were more interested in the still life, particularly the musical still life. A chain of artists responded to one another, creating a kind of pictorial conversazione, witty and captivating, about the nature of love. Two pictures, Orazio Riminaldi's (1586/93–1630) *Amor Victorious* and Manetti's *Victorious Earthly Love*, dramatise two sides of Cupid, one an inspiration to noble thought, the other conveying his mischievous and fatal power (figs 15 & 16).

Riminaldi's Cupid is grander than Caravaggio's. He suggests not the provocative sexuality of an antique god but, his flesh more luminous, the nobler forms of the Ludovisi Mars, *c*.100–200 BC (Museo Nazionale Romano, Palazzo Altemps, Rome); he dominates a balanced composition framed by a still life of unusual, sharp clarity.[30] The Neoplatonic philosopher Marsilio Ficino (1433–1499) had written that 'love is the master and governor of the arts' and this is Ficino's Cupid, exhorting the viewer to practise the arts.[31] Around him are symbols of harmony. The god of war's mighty sword is garlanded by a tambourine and, beneath a balance suggesting the power of the arts to restore the equilibrium between body and soul, bees buzz around the cast-off armour, for from the trials of war comes the sweetness of peace.[32] Cupid holds both cittern and pike, the sharp point of the pike directing the eye to the musical notation, a vivid plea for the union of the arts of peace and of war. Love, Ficino had written, 'may rightly be called the eternal knot and link of the world, and the immovable support of its parts'.[33] Far removed from erotic humour, the painting offers a new, positive interpretation of the myth of Mars and Venus.

In sharp contrast is the *Victorious Earthly Love* by Manetti, a Sienese artist who may have visited Rome in the 1610s.[34] Manetti returns to the infant Cupid of Greek poetry; his now prettily coloured Sienese wings are poised for flight, his grin cheeky and his tongue provocatively sexy. He stands poised to wield his fatal power and the arrowhead's sharp tip seems to echo his penis, with its emphatic shadow.[35] This Cupid, and many of his attributes, derive directly from

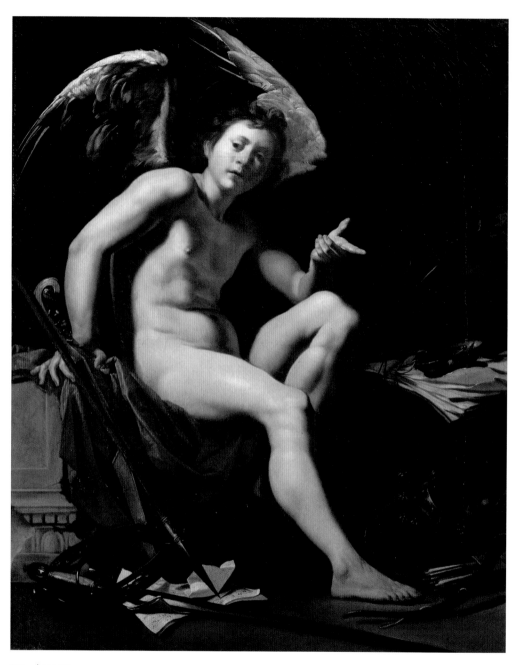

FIG.15 | ORAZIO RIMINALDI
Amor Victorious, 1624–25
Oil on canvas, 142 × 112 cm
Galleria Palatina, Palazzo Pitti, Florence

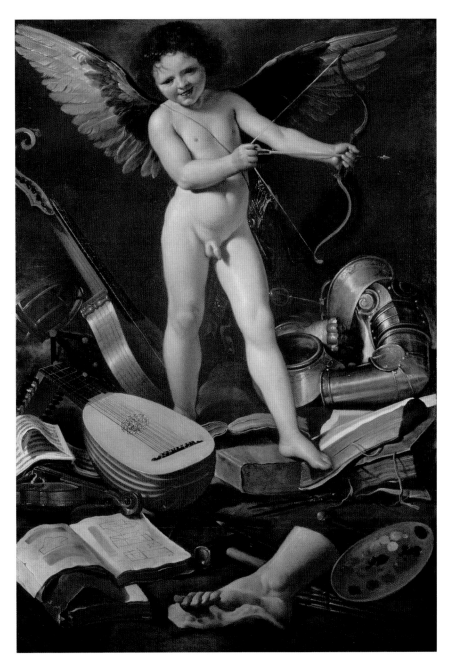

FIG.16 | RUTILIO MANETTI
Victorious Earthly Love, c.1625
Oil on canvas, 178 × 122 cm
National Gallery of Ireland, Dublin

the late sixteenth-century print, which would have been more easily available than Caravaggio's painting and which also inspired other artists. Manetti piles up around his figure symbols of the seven liberal arts, embellished by a set of armour and the attributes of painting, sculpture and architecture. His presentation is witty and playful, the jumble of objects suggesting the chaos that love can bring. The lute and cittern, painted with astonishingly precise realism, were both instruments prized by refined amateurs, but here, instead of indicating harmony, they are associated with love and seduction and their swelling shapes jostle around Cupid's foot. They are very different in effect from Riminaldi's cittern, which was perhaps chosen because it looks back to the cithara of ancient times. The vast armour of Mars, set against the music of love, shines impotently beside the small figure, his might brought low by a naughty infant. A fragment of a large, ancient marble foot leads the eye to the dainty but all-powerful feet of Cupid, who threatens the arts of both painting and sculpture. The array of objects seems to suggest the studio of a still-life painter or the atmosphere of a small private museum, with musical instruments and fragments of ancient marble.[36] The violin is coated in dust, and Manetti here added to his rendering of musical instruments, whose airs will soon fade, a hint of the brevity and transience of all human achievement. Cupid himself, his legs stiff and awkward, seems like a studio prop and yet he comes to warm life, a kind of living allegory recalling many poems written to statues of Cupid. Manetti takes up the theme of the *paragone*, comparing painting and sculpture and bringing a stone Cupid to life to triumph over the arts and the sciences.[37]

GUIDE THY STEPS HERE IN SILENCE …

In 1608, in Malta, Caravaggio painted *Sleeping Cupid*. This was almost certainly a gift for Francesco dell'Antella (1567–1624), a Florentine Knight of Malta, man of letters and of war, a distinguished connoisseur and collector who sent it to his family in Florence a year later. The painting is a link between the harsh and inquisitorial world of Malta, where sensuous mythological painting was entirely unknown, and the literary and artistic culture of Florence. For a Knight of Malta, dedicated to chastity and celibacy, the austere painting may have suggested tranquillity, the calm of mind and spirit achieved once sensual passion is overcome.

In Florence, however, it gathered other meanings, inspiring an extraordinarily rich and evocative imagery. Dell'Antella, as Giustiniani had before him, delighted in the possession of his Cupid; he called it '*mia gioia*'; he wrote that his pleasure in '*mio Cupido*' had been increased by a sonnet addressed to it; he coaxed praise from distinguished poets, encouraging the pleasure of conversazione, perhaps to explore Cupid's mysteries and ambiguities.[38] In 1620 the famous Florentine painter, Giovanni da San Giovanni (1592–1636), copied the painting onto the façade of Dell'Antella's family palace overlooking the Piazza Santa Croce, the centre of a decorative scheme celebrating his family. The red drapery on which Cupid lies is inscribed '*Tranquillitas Animi*' ('peace of mind'), privileging a reading of the painting as conveying the virtuous stilling of the passions. Dell'Antella may well have been consciously emulating Isabella D'Este, whose Cupids bestowed lustre upon her, and the subject became the attribute of noble collectors in Tuscany and Bologna.

Caravaggio's first idea was to paint an allegory of sleep, with Cupid on a cushion and with an owl and poppy, symbols of sleep and death, beside him; in the end he instead painted a vivid small boy, between infancy and childhood, and wrapped him in mysterious darkness.[39] He may well have remembered Gaspare Murtola's (*c*.1550–70–*c*.1624) advice that, should he wish to paint love, he might paint 'that beautiful little Giulietto', for 'both are pretty, both are fond'.[40] Only a touch of red on the arrow relieves the sombreness of the colours. The painting is provocatively naturalistic and would have been more charmingly so when the condition was better. One hand rests, relaxed, on Cupid's side; the strings of his bow are loosed and his threatening quiver now a pillow; his other hand, however, still clutches an arrow, slightly tensed for action. The painting has something of the fresh naturalism of the famed Hellenistic bronze (fig.1), and a *Sleeping Cupid with a Poppy* (Galleria degli Uffizi, Florence) of that period was well known in Florence at that time; Dell'Antella may too have encouraged Caravaggio to emulate Michelangelo's (1475–1564) legendary *Sleeping Cupid*, *c*.1495–96 (now lost), then displayed in Mantua with an antique Cupid attributed to Praxiteles. In Mantua too, in 1506, at the court of Isabella D'Este, the acquisition of an antique Cupid 'rendered as if it were dead' took place.[41]

FIG.17 | MICHELANGELO MERISI
DA CARAVAGGIO
Sleeping Cupid, 1608
Oil on canvas, 71 × 105 cm
Galleria Palatina, Palazzo Pitti, Florence

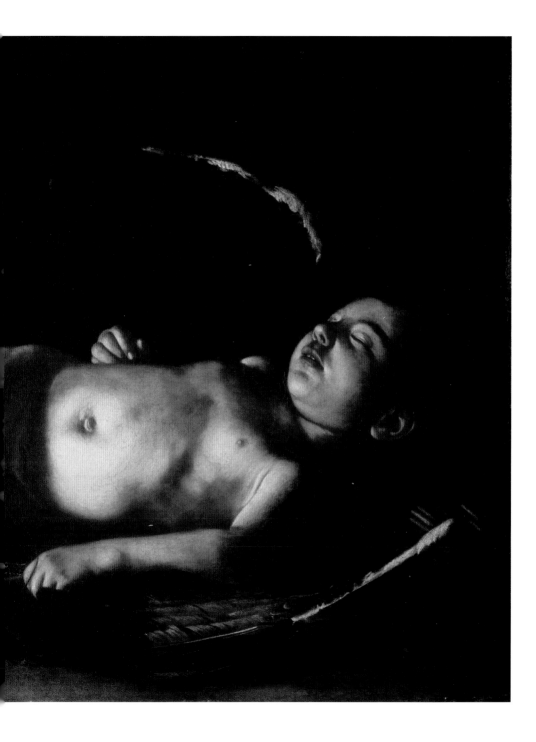

Caravaggio's Cupid is disempowered, suggesting tranquillity, and yet culti-vated viewers would have enjoyed his ambiguities, for the small sleeping god remains dangerous; he is the 'weaver of wiles' for, even as he sleeps with his bows and arrows cast off, in his dreams he conjures up new cruelties. An epigram attributed to Plato presents Cupid sleeping by a fountain, where the image of a satyr warns the viewer, 'Guide thy steps here in silence, lest thou disturb the boy lapped in soft sleep'.[42] The wanderer should tread warily and flee his malicious power. It is perhaps this peril that the ready arm of Cupid, still clutching his arrow, intended. To some viewers this Cupid has seemed dead and Caravaggio played on the poetic theme of the blurred boundaries between sleep and death; Ovid had exclaimed, 'Fool! What else is sleep but the image of chill death?' and the close mythological connections between night, sleep and death were to inspire a rich imagery.[43] Caravaggio may be setting the mocking naturalism of his small god against the grandeur of Michelangelo's mighty goddess, *Night,* begun in 1524 (San Lorenzo, Florence), which had revived these connections. Very delicately, too, Caravaggio evokes the presence of the mortal Psyche, with whom Cupid himself, unusually, had fallen in love as in a story told in Lucius Apuleius' (*c.* AD124– after 170) *The Golden Ass.* Psyche's beauty had enraged Cupid's jeal-ous mother, Venus, so Cupid visited Psyche in secrecy and at night, hiding his identity in darkness and forbidding Pysche to see him. But Psyche disobeys, and daringly holds up a lantern to glimpse the god as he sleeps, waking him with a drop of wax. Cupid, angered by her defiance, banishes her and Psyche suffers several years of painful wandering before the two are reunited. The pattern of light here suggests her presence beyond the picture, and the viewer themself seems to hold her lantern, fearful of Cupid's anger.[44] In an extraordinary way, Caravaggio creates an amusing and challenging image that utterly grips the beholder, and weaves together a suggestive variety of images and poetic echoes.

The subject became immensely famous; it was popular not only in Tuscany but also with Bolognese artists and collectors. Noble patrons saw antique and modern Cupids as status symbols, conveying their refined skills as collectors.[45] It spread rapidly among Caravaggio's contemporaries and, as with the *Cupid Victorious,* painters emulated, criticised and developed it. A small group of

paintings begins this variety of responses to Caravaggio's work. First come two Cupids by Giovanni Battista Caracciolo (1578–1635), a Neapolitan artist who was called to Florence by the Medici in 1617 and who would certainly have known the painting (figs 18 & 19). His Cupids themselves form a sharp contrast. The *Sleeping Cupid* in Palermo is the smallest and perhaps the first; it shows a young boy of perhaps four or five, presented with fresh naturalism, at first sight simply a study of a sleeping child with no wings or other attributes. He lies on the earth and is wrapped in darkness, as is Caravaggio's Cupid. But, slowly, the skull on which he rests emerges from the shadows before the viewer and the shocking juxtaposition of his bright youth with the stark and fleshless reminder of death transforms the theme.[46] The association of the child with death had a long history and the motif of the putto with the skull circulated widely; Caracciolo may well have been acquainted with Barthel Beham's (*c*.1502–1540) print of a *Child Sleeping on a Skull*, 1525, or with a well-known late fifteenth-century Italian woodcut, *L'Hora Passa* ('The Hour Passes'), showing a putto with a skull and hourglass. Many seventeenth-century lyrics lament how swiftly man, born to die, moves from the cradle to the grave. But, above all, this painting suggests that Caracciolo saw Caravaggio's painting as a dramatic play on the likeness of love and death.

Caracciolo's other *Cupid Sleeping*, which I would suggest is slightly later and a more elaborate version of the Sicilian painting, presents a more sensuous body, slightly older, with something of the grace of Hellenistic sculpture. Caracciolo no longer pares down his subject: he weaves around him the attributes of Cupid, now arming him with an unusually large bow; beside him, in the flowery meadow, blooms the bright red poppy of sleep. The setting suggests Ovid's description of the secret dwelling place of languid sleep, a rocky cave whence flows the River Lethe, where poppies and herbs bloom in abundance and where the god lies, his limbs relaxed in luxuriant weariness.[47] The spring-like flowers suggest the frailty of youth and beauty. Significantly, the painting went to Mantua, where Vincenzo Gonzaga (1562–1612) was the proud possessor of Caravaggio's *Death of the Virgin*, 1601–05/6 (Musée du Louvre, Paris) and where, at the D'Este court, poets had celebrated Michelangelo's Cupid.

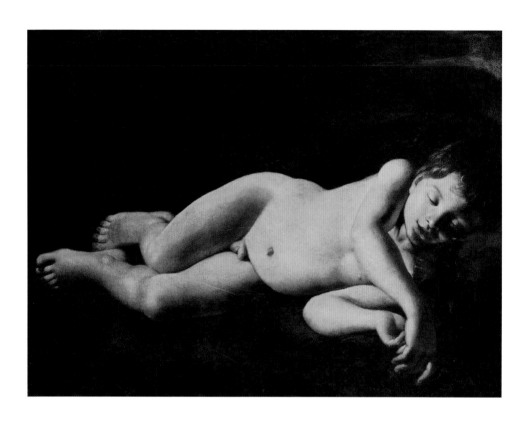

FIG.18 | GIOVANNI BATTISTA CARACCIOLO
Sleeping Cupid, before 1617
Oil on canvas, 72.5 × 96.5 cm
Palazzo Abatellis, Palermo

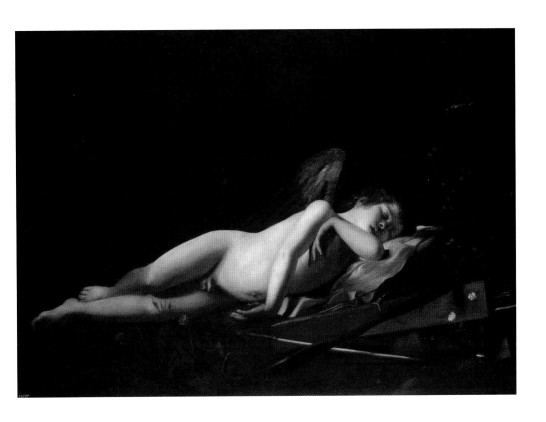

FIG.19 │ GIOVANNI BATTISTA CARACCIOLO
*Cupid Sleeping, c.*1618
Oil on canvas, 92.3 × 127.1 cm
The Royal Collection, Hampton Court, London

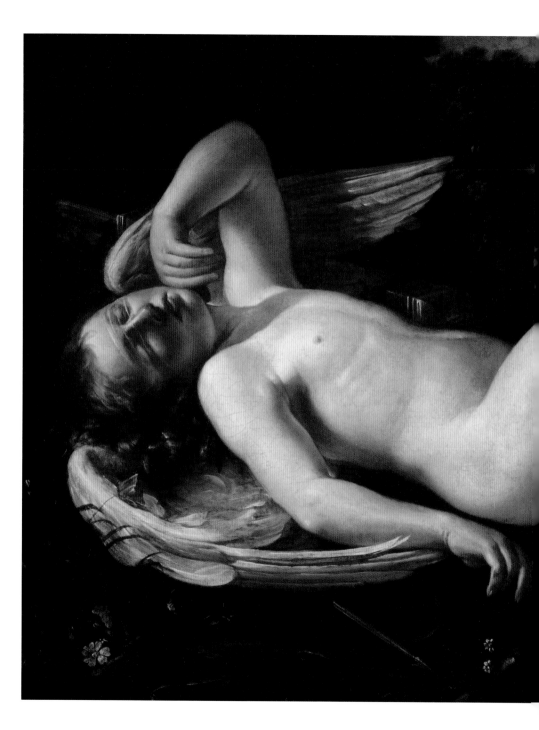

FIG.20 | ORAZIO RIMINALDI
*Cupid Asleep Approached
by Venus in her Chariot,
c.1628–30*
Oil on canvas, 84 × 114.5 cm
National Trust, Kedleston Hall,
Derbyshire

FIG.21 | LUCAS CRANACH THE ELDER
Cupid Unblinding Himself, c.1530
Oil on panel, 79.1 × 38.1 cm
Philadelphia Museum of Art, Philadelphia

Caracciolo's Cupids separate and re-present two of the ideas, death and sleep, so cleverly interwoven in Caravaggio's painting. Orazio Riminaldi's *Cupid Asleep Approached by Venus in her Chariot* again takes Caravaggio's work as its starting point, but blends it with a subject popular with Bolognese artists: that of Cupid sleeping in a landscape (fig.20). His Cupid shines in a bright and sunny meadow; he is strikingly naturalistic, painted from a live model, his feet curled one under the other. Yet he is set like a sculpture against a bed of flowers, a poppy bright against the dazzling whiteness of his wings. In the sky above, Venus, in her dove-drawn chariot, searches through a spreading landscape for her son, so close to the viewer yet unseen by his angry mother. The subject has overtones of Moschus' idyll, where Venus searches for the runaway Cupid through palaces, towns and the countryside. Yet it is drawn from Apuleius' *The Golden Ass*, which tells how Venus, inflamed by jealousy of the fame and beauty of the mortal Psyche, seeks help from her malicious son, 'rash and hardy', who 'doth nothing but that which is evil'.[48] She sends him to punish Psyche but Cupid, who rarely suffers, is himself blinded by love for her. Riminaldi's is the Cupid of Apuleius, his hairs of gold drenched with ambrosia, 'his ruddy cheeks upon which his hair hanged comely behind and before', his plume of wings shining on his gleaming shoulders and 'the tender down of their edges trembling hither and thither'.[49] It is a highly sensual portrayal, suggesting Cupid's wickedness by the erotic stress on his bottom, the eye playing over the shadowed crack between his legs. Marino had retold this story in his epic poem 'Adone' and here the landscape, with its obelisks and monuments, conveys the breadth of travels that Cupid himself describes in Marino's poem, while the meadow has something of the highly wrought beauty of Marino's verse.[50]

Amongst the flowers in the foreground is a butterfly, an attribute of Psyche and a symbol of the soul (the meaning of Psyche's name), opening up a Neoplatonic reading of the painting. The many punishments that Psyche was to endure, and her search for Cupid and eventual reunion with him, could be read as a long quest for reconciliation with the divine origins of the soul. The almost transparent blindfold adds another layer of meaning. The blindfold, very rare in classical literature and unknown in classical art, meant, at its most obvious, that the lover is blind to

faults; alternatively, it could mean that we lead improper lives on account of the fire of love. Here Cupid himself has become blind love, in thrall to the senses. Yet the image can also be positive. Through love, we remove the blindfold and ascend to the spiritual; we perceive true beauty and attain wisdom. This concept lies behind Cranach's use of transparent veils, and his small *Cupid Unblinding Himself* shows the child in dancing pose on a block of stone, perhaps about to leap into the air. He lifts his blindfold and smiles engagingly at the spectator (fig.21). A later artist, perhaps in the sixteenth or early seventeenth century, replaced the pedestal with a volume of the *Works of Plato*, transforming him yet more emphatically into a Platonic Cupid. This overpainting was removed during cleaning in 1973, but it suggests how the painting was once read.[51] Riminaldi may have known such a motif, and his roguish Cupid with his gauzy blindfold is at the start of a spiritual journey.[52]

'I SLEEP, BUT MY HEART WAKETH': SONG OF SONGS 5:2

Sleep, for the Neoplatonic philosopher Ficino, could be virtuous; it could, as a kind of contemplation, lead to spiritual heights and a rediscovered closeness to the divine. Sleep stilled the passions and encouraged the cultivation of the liberal arts; as physical activity lessened, so the mind and the imagination became freer and more intense. In my final image the Neoplatonic reading, just suggested in the Riminaldi, becomes very clear. Here, in a painting attributed to the workshop of Manetti, a Cupid sleeps over the symbols of the arts (fig.22). Through the arts, he is now the gateway to a higher wisdom, whereas before he had cheekily trampled on all the noblest accomplishments of humankind.[53] He is perhaps the last twist in a very rich chain of images flowing from Caravaggio's two Cupids, which so engage the viewer and so brilliantly suggest a variety of readings.

I should like to thank Letizia Treves for her encouragement in this project, and Jane Kingsley-Smith and Giulia Martina Weston for discussing ideas with me. I am also indebted to the careful editing of Gillian Achurch. HL

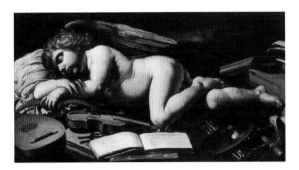

FIG.22 | WORKSHOP OF RUTILIO MANETTI
Cupid Sleeping over the Symbols of the Arts, c.1630–40
Oil on canvas, laid on board, 72.5 × 122 cm
Private collection

NOTES & REFERENCES

1. Versions of the first work are in the Museo Archeologico Nazionale, Venice, and in the Musei Capitolini, Rome. In the fifteenth century a Cupid in the collection of Isabella d'Este was thought to be the Praxitelean Cupid (Campbell 2004, p.95).

2. Campbell 2004, p.95.

3. *Greek Anthology* 1919, 16.211 & 212.

4. *Greek Anthology* 1919, 9.440. See also Leporatti 2002, p.76.

5. Alciato 2009, Emblem LXXII, *Amor virtutis, alium Cupidinem superans*, pp.386–92.

6. Alciato 2009, p.497.

7. *Beyond Caravaggio* was shown at The National Gallery, London, from 12 October 2016 to 15 January 2017; at the National Gallery of Ireland, Dublin, from 11 February to 14 May 2017; and at the Scottish National Gallery, Edinburgh, from 17 June to 24 September 2017.

8. De Mirimonde (1967, p.319) reproduces another, very similar print of *Omnia Vincit Amor*, which he dates to the fifteenth century and which shows many of the symbols used by Caravaggio. It is very close to the sixteenth-century print. De Mirimonde comments that Caravaggio, so audacious in his technique, is traditional in his symbolism.

9. Röttgen 2006, p.49.

10. Röttgen 2006, p.62.

11. Strunck 2001, p.109. Strunck illustrates a reconstruction of the entrance wall of the *galleria*.

12. Joachim von Sandrart, as given in Hibbard 1983, p.378.

13. Weston 2016, p.146. Weston has a section on the iconography of sleep.

14. Ovid *Met.* 1.452.

15. *Greek Anthology* 1919, 9.440.

16. *Greek Anthology* 1919, 12.15. For this translation, see Skelton 1971, p.68. A book of the *Greek Anthology* was devoted to homoerotic poems and several had been translated into Italian. Something of the tone of this kind of poem may well have percolated into the learned circles around Giustiniani. For a particularly clear discussion of the homoerotic implications of the painting, see Varriano 2006, pp.64–66.

17. The model has often been described as the painter, Cecco del Caravaggio, and further identified as Caravaggio's lover. To the present writer the evidence for this seems doubtful. See Wiemers 1986.

18. Plato *Symposium* 211d.

19. Mancini, quoted in Hibbard 1983, p.350.

20. Fernando Marias, in Aurigemma 2013, no.6, pp.180–81.

21. Barstch 1985, 28.42.2.

22. Bartsch 1985, 28.52.

23. On this painting, see Fernando Marias, in Aurigemma 2013, no.6, pp.180–81. The date of the painting is not clear; in the present writer's opinion it must follow Caravaggio's *Cupid Victorious* and probably dates from about 1603.

24. Cavazzini 2014, p.139.

25. Maccherini 1997, p.71.

26. Maccherini 1997, p.88, footnote 11.

27. Lucian 1961, 19.232.

28. The fresco is now detached and in The National Gallery, London.

29. Rinaldi 1603, pp.107–19.

30. Carofano (2005a, pp.225–32) provides an account of the iconography and compares the painting with another more Caravaggesque version in a private collection in Milan.

31. Ficino 1985, p.66.

32. Alciato 2009, pp.260–61. Emblem XLV, *Ex bello pax*.

33. Ficino 1985, p.68.

34. The attribution of this painting is controversial. It was exhibited in *Beyond Caravaggio* as by Manetti, and I have followed this attribution here. For the picture's relationship to the anonymous sixteenth-century print, see Sergio Benedetti, in Bini, Strinati & Vodret 2000, cat.21, p.156.

35. Hart and Stevenson 1995, p.68.

36. See, for example, Maestro dell'Annuncio ai Pastori, *Lo Studio del pittore, c.*1639 (Colección Masaveu, Oviedo) reproduced in Ferino-Pagden 2001, p.125.

37. De Mirimonde 1967, p.320 (as Riminaldi) and Sergio Benedetti, in Bini, Strinati & Vodret 2000, p.156, no.21.

38. Sebregondi 2005, XLV–XLVI.

39. Lapucci 1991, pp.310–17.

40. Murtola 1604, p.216. This is one of a group of madrigals addressed to a baby, Giulietto, and it seems likely that Murtola is suggesting the subject to Caravaggio rather than describing a painting by him.

41. Campbell 2004, p.92.

42. *Greek Anthology* 1919, 9.826.

43. Ovid 1977, 2.9.41.

44. Pizzorusso 1983, pp.54–55.

45. Weston 2016, p.145.

46. Rosen 2009, p.217.

47. Ovid *Met.* 11.573–649.

48. Apuleius 1919, 4.30.

49. Apuleius 1919, 5 22.

50. It seems possible that the landscape is by another artist. The style suggests the landscapes of Agostino Tassi (*c.*1580–1644) in Rome, or perhaps of Filippo Napoletano (*c.*1587–1629), who developed the naturalism of Roman landscape in Florence. At the same time it looks back to such a print as Bonasone's *Mercury Telling the Story of Pan and Syrinx, c.*1567. Barstch 1985, 102.

51. Taylor 2015, pp.10–11.

52. It could be argued here that the insubstantiality of the veil is due to the painting's condition, as, in Carlo Faucci's (1729–1784) eighteenth-century print after the picture, it appears more solid. The veil may well be gauzier than intended, but the care with which the artist has painted the eyes suggests that it was never meant to be entirely opaque.

53. Weston (2016, pp.141 & 147) describes a painting by Niccolò Tornioli (1606–1651) that is listed in an inventory as '*Amore che dorme sotto l'Arti Liberali*' ('Cupid sleeping under the liberal arts'). She suggests that this was Cupid sleeping over the liberal arts and that Tornioli may have been relying on Manetti here. For the Manetti, see Ciampolini 2010 I, p.310.

BIBLIOGRAPHY

ALCIATO 2009
Alciato, Andrea, *Il Libro degli emblemi secondo le edizioni del 1531 e del 1534*, Mino Gabriele (trans. & ed.), Milan, 2009

APULEIUS 1919
Apuleius, Lucius, *The Golden Ass: Being the Metamorphoses of Lucius Apuleuis*, William Adlington (trans. 1566), Stephen Gaselee (rev.), London, 1919

AURIGEMMA 2013
Aurigemma, Maria Giulia, *Carlo Saraceni, 1579–1620: Un Veneziano tra Roma e l'Europa*, Salone Monumentali del Palazzo di Venezia, Rome, 2013

BARTSCH 1985
Bartsch, Adam von, *Italian Masters of the Sixteenth Century*, vol. 28, Suzanne Boorsch & John Spike (eds), New York, 1985

BINI, STRINATI & VODRET 2000
Bini, Annalisa, Strinati, Claudio & Vodret, Rossella (eds), *Colori della Musica: Dipinti, strumenti e concerti tra Cinquecento e Seicento*, Milan, 2000

CAMPBELL 2004
Campbell, Stephen, *The Cabinet of Eros: Renaissance Mythological Painting and the Studiolo of Isabella d'Este*, New Haven & London, 2004

CAROFANO 2005
Carofano, Pierluigi (ed.), *Luce e Ombra: caravaggismo e naturalismo nella pittura toscana del Seicento*, Pisa, 2005

CAROFANO 2009
Carofano, Pierluigi, 'Sulle due versioni dell'Amore Vincitore di Orazio Riminaldi', in *Atti delle Giornate di Studi sul Caravaggismo e il Naturalismo nella Toscana del Seicento*, Pierluigi Carofano (ed.), Pontedera, 2009, pp.225–39

CAVAZZINI 2014
Cavazzini, Patrizia, 'Queste lascive immagini sono altari dell'Inferno': Dipinti provocanti nelle dimore romane del primo Seicento', in *I Pittori del Dissenso: Giovanni Benedetto Castiglione, Andrea de Leone, Pier Francesco Mola, Pietro Testa, Salvator Rosa*, Stefan Albl, Anita Viola Sganzerla & Giulia Martina Weston (eds), Rome, 2014, pp.130–45

CIAMPOLINI 2010
Ciampolini, Marco, *I Pittori senesi del Seicento*, 3 vols, Siena, 2010

DE MIRIMONDE 1967
De Mirimonde, Albert Pomme, 'La Musique dans les allégories de l'Amour II – Eros', *Gazette des Beaux Arts*, 69, 1967, pp.319–46

FERINO-PAGDEN 2001
Ferino-Pagden, Sylvia (ed.), *Dipingere la Musica: Strumenti in posa nell'arte del Cinque e Seicento*, Milan, 2001

FICINO 1985
Ficino, Marsilio, *Commentary on Plato's Symposium on Love*, Jayne Sears (trans.), Dallas, 1985

GREGORI 1991
Gregori, Mina (ed.), *Michelangelo Merisi da Caravaggio: Come nascono i capolavori*, Milan, 1991

HART & STEVENSON 1995
Hart, Clive & Stevenson, Kay Gilliland, *Heaven and the Flesh: Imagery of Desire from the Renaissance to the Rococo*, Cambridge, 1995

HARTJE 2004
Hartje, Nicole, *Bartolomeo Manfredi (1582–1622): ein Nachfolger Caravaggios und seine europäische Wirkung: Monographie und Werkverzeichnis*, Weimar, 2004

HIBBARD 1983
Hibbard, Howard, *Caravaggio*, New York, 1983

HUTTON 1935
Hutton, James, *The Greek Anthology in Italy to the Year 1800*, Ithaca & London, 1935

LAPUCCI 1991
Lapucci, Roberta, 'Amorino dormiente', in *Michelangelo Merisi da Caravaggio: Come nascono i capolavori*, Mina Gregori (ed.), Milan, 1991, pp.311–16

LEPORATTI 2002
Leporatti, Roberto, 'Venus, Cupid and the Poets of Love', in *Venus and Love: Michelangelo and the New Ideal of Beauty*, Franca Falletti & Jonathan Katz Nelson (eds), Florence, 2002, pp.65–89

LUCIAN 1961
Lucian, *The Dialogues of the Gods*, vol. VII, M.D. Macleod (trans.), London & Cambridge, 1961

MACCHERINI 1997
Maccherini, Michele, 'Caravaggio nel carteggio familiare di Giulio Mancini', *Prospettiva*, 86, 1997, pp. 71–92

MACIOCE 2003
Macioce, Stefania, 'Caravaggio and the Role of Classical Models', in *The Rediscovery of Antiquity: The Role of the Artist*, Jane Fejfer, Tobias Fischer-Hansen & Annette Rathje (eds), *Acta Hyperborea*, 10, Copenhagen, 2003, pp.423–45

MENDELSOHN 2002
Mendelsohn, Leatrice, 'How to Depict Eros: Greek Origins of the Malevolent Eros in Cinquecento Painting', in *Venus and Love: Michelangelo and the New Ideal of Beauty*, Franca Falletti & Jonathan Katz Nelson (eds), Florence, 2002, pp.90–108

MURTOLA 1604
Murtola, Gaspare, *Rime del Signore Gaspare Murtola*, Venice, 1604

OVID 1977
Ovid, *Heroides, Amores*, Grant Showerman (trans.), G.P. Goold (rev.), Cambridge, MA., 1977

PATON 1919
Paton, William Roger, *The Greek Anthology*, London, 1919

PIZZORUSSO 1983
Pizzorusso, Claudio, '"Un tranquillo dio": Giovanni da San Giovanni e Caravaggio', *Paragone*, 405, 1983, pp.50–59

RINALDI 1603
Rinaldi, Cesare, *Rime Nuove di Cesare Rinaldi*, Bologna, 1603

ROSEN 2009
Rosen, Valeska von, *Caravaggio und die Grenzen des Darstellbaren: Ambiguität, Ironie und Performativität in der Malerei um 1600*, Berlin, 2009

[47]

RÖTTGEN 2006
Röttgen, Herwarth, *Caravaggio: L'Amore terreno o la vittoria dell'amore carnale*, Modena, 2006

SEBREGONDI 2005
Sebregondi, Ludovica, 'Caravaggio e la Tosacana', in Carofano 2005, pp.XLI–LIX

SKELTON 1971
Skelton, Robin (trans. & ed.), *Two Hundred Poems from the Greek Anthology*, London, 1971

STRUNCK 2001
Strunck, Christina, 'L'"humor peccante" di Vincenzo Giustiniani: L'innovativa presentazione dell'Antico nelle due gallerie di Palazzo Giustiniani a Roma (1630–1830 circa)', in Silvia Danesi Squarzina, *Caravaggio e i Giustiniani: Toccar con mano una collezione del Seicento*, Milan, 2001, pp.105–14

TAYLOR 2015
Taylor, Paul, *Condition: The Ageing of Art*, London, 2015

TREVES ET AL. 2016
Treves, Letizia *et al.*, *Beyond Caravaggio*, London, 2016

VARRIANO 2006
Varriano, John, *Caravaggio: The Art of Realism*, University Park, PA., 2006

WESTON 2016
Weston, Giulia Martina, *Niccolò Tornioli (1606–1651): Art and Patronage in Baroque Rome*, Rome, 2016

WIEMERS 1986
Wiemers, Matthias, 'Caravaggio's "Amore Vincitore" im Urteil eines Romfahrers um 1650', *Pantheon*, 44, 1986, pp.59–61